CW00505554

CEREMONIALS OF COMMON DAYS

Ceremonials
OF
Common Days

ABBIE GRAHAM

Angelico Press

Contents

Contents

Ceremonials of Summer

Contents

Ceremonials of Autumn

My Own Ceremonials

A Foreword

That Really Should Be Read

THIS collection of the Ceremonials of a Year is an Anthology of the Wonder of Common Days. It would be arrogant to attach the closing flourish, "The End." The Ceremonials of a year are accumulative; they can never be concluded, as long as one lives on earth. Perhaps the Ceremonials of Earth will be continued in a sequel, The Ceremonials of the Ruppeny Moon. Spaces are therefore left for the private ceremonials of other people and for additional rites which we may wish to observe.

I have had internal controversies over the translation of my Ceremonials into words. My own Soul has

Foreword

so many different versions of each one that I have found difficulty in selecting a mean account which will truly describe the interior events.

Three words will appear in these pages that may have need of explanation, Soul and Heaven and Ceremonial. The words Soul and Heaven will have no philosophical nor theological connotation. Soul will be used as a symbol to represent the most important part of a person, the part that is admitted into Heaven. Heaven will refer to the place we think of when we think very quickly, before we have opportunity to consult any second-hand information. A Ceremonial may be interpreted as a spiritual obeisance to the created beauty of the world.

Ceremonials of Winter

Christmas Eve

THE Ceremonial of Christmas Eve begins when it is dark enough for stars, and for candles to be lighted. All Christmas letters are reserved for Christmas Eve. They are shuffled with much honesty and read in order. One letter is written. Packages may not be opened on Christmas Eve. That would leave no wonder for Christmas Morning; that would mean that I had lost faith in Santa Claus, the incarnate spirit of Christmas. Christmas wrappers and silver cords and stickers and holly ribbon are saved to kindle the Christmas Morning fire. It is lavish fuel, but then Christmas Morning is lavish, too.

Winter

On Christmas Eve love is clothed with visible vestments, with gifts and written words, with holly-wreaths and flowers and candles. The love that through the year is silenced by "busy-ness" is expressed in terms of tangible beauty. Christmas Eve is the Ceremonial of Gifts, of gifts that are given to explain something which the heart cannot say.

As I watch the Christmas candles burn, I see in them a symbol of the Great Love which dipped a lustrous spirit into human form that the world in its darkness might be illumined and made beautiful.

New Year's Eve

O N New Year's Eve I am at
home to the Future. I wait
to hear her ring the doorbell
of the world.

I do only expectant things on this
evening. I write a letter to an un-
known person who has done some-
thing that I admire, a person whom
I would like to know. I make two
New Year resolutions, one rather
idealistic, the other extremely prac-
tical. The former is more for special
occasions; the latter is for rough,
everyday use. "To stop accumulat-
ing bundles when I travel," has been
a very successful resolve of the latter
type. Another in this same category
I recommend highly, "When in small

towns to use my mouth for purposes of food and ventilation only."

There is no hurry on this evening. With much leisure I make preparation for the guest who is to come and for the gifts that she will bring. I set my house in order. There is always a keen sense of failure when I find that its appointments are so meagre, its proportions so inadequate. I would have my house more in keeping with the royal character of my guest.

Before I am aware of her approach, a mighty shouting heralds her coming; I open the door. The gorgeous guest from afar sweeps in. In her hands are her gifts—the gift of hours and far-seeing moments, the gift of mornings and evenings, the

Fourteen

gift of spring and summer, the gift of autumn and winter. She must have searched the heavens for boons so rare.

What happiness there is when I awake to find near me the gift of a Morning!

Letters

EVERY letter is something of a miracle. A soul dictates its thoughts. Queer markings appear on a piece of paper. The paper is sealed and stamped. Other signs are placed on the outer covering. The little packet is intrusted to utter strangers. It arrives. It is translated by another soul. It may transform a day—those hieroglyphics of a soul.

In regard to letters there are certain ordinances which my soul has decreed shall be performed. The outer ordinances are of lesser importance: to buy my year's supply of stamps, if geographically possible, at the United States Post Office at

Winter

Washington; to use post offices in cities for the mailing of letters, rather than mail-boxes; never to pass our small-town post office without interviewing our post office box; to resent the desecration of one's post office box by commercial propaganda.

The more significant ordinances observed are the inner ones. Epistolary wranglings are forbidden; wrath must be telegraphed or saved for an interview. Letters are removed from the realm of obligatory documents; they are a free-will offering. The ability to transmute one's innermost thoughts and desires into postal merchandise is no mean undertaking. The success of reducing one's ambitions to portable form should be wondered at; but a failure to accomplish

it should not be censured. I would make my letters worthy of that national interpretation of the meaning of letters which is carved on the United States Post Office at Washington:

Messenger of Sympathy and Love
Servant of Parted Friends
Consoler of the Lonely
Bond of the Scattered Family
Enlarger of the Common Life
Carrier of News and Knowledge
Instrument of Trade and Industry
Promoter of Mutual Acquaintance
Of Peace and Good Will
Among Men and Nations.

On the Eve of Being Bored

THE Eve of Being Bored is not restricted to seasons and it comes unheralded. It may occur at these times: when locked out of one's apartment; when waiting for people, street cars, elevators, and trains; while "central" is getting ready to answer; when one has just missed a train; when people talk long after they have finished; on crowded subways; when it becomes necessary to have one's picture taken; when thrust upon the front seat on semi-social occasions in small towns.

To be bored is a mark of intellectual laziness, of lack of spiritual com-

prehension. I always feel inferior when I begin to be bored. It is as if I have not the power to live up to the occasion. Therefore, I have sought means of fortifying my soul against this event in the calendar. At one time, when locked out of an apartment at a critical moment, I walked out on the Drive and played with the angel on the pinnacle of the cathedral. (I do not know why Journalism has not thought of interviewing that winged messenger from afar. In that city foreign guests are usually very popular with interviewers.) But usually there are no angels in sight; the angels seem busy with their own celestial affairs and one is left to one's interior divinations and artful stratagems.

Twenty

Winter

Often I organize Associations That Are Needed and Conventions That Should Assemble and Committees That Should Make Recommendations. I have at such times organized a Fire-Builders' Association. I call a convention of this Association and appoint committees. One wing of the convention is made up of those who like to build outdoor fires; the other wing is composed of those who prefer building indoor fires. A permanent chairman has been appointed for the former wing and permanent sub-chairmen have been selected to assist with the latter. The convention floor is the scene of heated arguments over the best methods of making fires, but the controversies are happy ones, for only

friendly souls enjoy making fires. We legislate against those who build fires with paper and kerosene; who do not extinguish camp-fires when they leave. We discuss the most practical kinds of grates for cooking over outdoor fires. At intervals we sing mystic fire-chants. And always we serve coffee, made in a big, black pot, under some pine tree or on some hilltop.

It is very good to organize this association when waiting for a train on a cold day, or when people talk too long. Before the coffee is finished, fellow travelers begin to collect suitcases and children, and the baggage trucks are rolled in place; or the people who were discoursing on "The Universe and the Things Contained

Therein," have concluded, and possibly departed.

In crowded subways I organize Real Estate Companies Who Sell Portable Space. None of these companies has been completely organized and perhaps never will be, because of the many human and pictorial distractions in this form of underground traffic. It is difficult to enforce any parliamentary law and order on a subway.

Another worthy enterprise to set in motion is an Insurance Company for Fountain Pens. On the basis of my own personal loss, I make estimate of the number of fountain pens that must be lost every year in my town, in my county, in my nation, in my world; and if central has not

answered by then, I make computations regarding interworld losses. In the centers which I consider to be the most lucrative for my insurance business I post placards advertising my company. These centers are: schools, colleges and universities; writing desks in department stores, banks and trains; at all conventions and conferences; at every geographical spot where a friend borrows a fountain pen "for just a moment."

The diversities of opinions, tastes, and practices furnish material for innumerable live societies and unions, namely, people who like to sleep and people who do not; people who do their own laundry and people who have it done; people who like rain and people who do not; people who

enjoy going to fires at night and people who do not; people who have hay fever and people who do not; people who monopolize the bathroom before breakfast and people who do not, and so on. These societies are recommended for the front-seat occasions in social circles, because an audience makes it possible to visualize one's classifications.

Other Occasions on Which One Is Bored

Other Organizations That May Be Set Up

Ceremonials of Spring

The First Fruits of My Garden

RADISHES usually come first — radishes — s m a l l , round, and red. When I take them from the ground into which I had placed only seeds, and tie them in small bundles, I quite understand why those other gardeners had to give their first fruits to God. It is impossible to use one's first radishes and lettuce and beans merely for food. Later in the season the wonder of these growing things may lessen, but on that first day a garden is a miracle, and something of it must be given to God. I envy those ancient farmers. I wish that I, too, might find some high altar whereon I

might make my offering to the God of Gardens.

And yet, I have neighbors who like early vegetables. Very early in the morning, while the morning-glories are yet on the fences, I make bundles of red and green. I call over a back-yard fence and lift high my offering, and the gods accept my sacrifice.

There is something that celebrates itself within me on The Day of the First Fruits of My Garden. It is a song of joy for created things—joy that a seed planted in the ground will bring forth its fruit in its season; that a dream intrusted to the soil of a human heart will bring forth its harvest of an hundred fold.

Vagabond Rites

VAGABOND rites are not in-
tended for habitual wanderers
but for the people who must needs
live behind the conventional walls
and regularly pursue official duties.
The time for vagabond rites to be
observed is whenever life gets too
minutely blue-printed and too ines-
capable.

There are lesser pilgrimages. I go
forth insulated from previous preju-
dices and make up my mind anew. I
go companionless, with no destina-
tion in view. My way may be along
a village street or through a city
park. Some days I hear only the
sounds—church bells ringing, a child
crying at dusk, whistling, voices on

front porches or at windows, foot-steps, dogs barking, silences. At other times I am aware only of odors—leaves burning, coffee being parched, watered gardens, freshly cut grass, four-o'clocks and locust trees in bloom. There is a special pilgrimage which I make in spring. It leads by an orange orchard. There comes a sudden fragrance to greet me while I am yet afar off. I advise every pilgrim to include this little country road in his journey-ings. There is the pilgrimage of color: pink petunias, blue mists, lights in little houses, the sky at sun-set and a star.

I have more pretentious rites. I buy a railroad ticket and venture forth on trains and look out at other

people's gardens. I spend the night in a hotel where there are finger bowls for breakfast and a head waiter with his attending staff, and unknown people. I write letters; I look out at the sea from new windows; I sleep, and wake with surprise at seeing strange walls; I prepare for my departure; I read the little signs, "Please Turn Off the Lights," "Stop! Have You Left Anything, Your Overcoat, Your Tooth Brush, Your Shaving Mug?" The porter facetiously assists with my small bag and I return home as if from a long sea voyage.

This Ceremonial loosens up tightened soil and conserves wonder.

Spring

THE Ceremonial of Roads I borrowed from the gypsies. It is the Ceremonial of the Romany Patteran. When the gypsies love a road they place there a little pile of stones, a Romany Patteran, that other gypsies may follow it. Though I am but a "Gorgios" and not of the Romany tribes, I, too, shall assist with the building of little roadside altars, that the footsteps of travelers may be guided in the ways of beauty.

Though the Romany Patteran is a distinctly Gypsy Ceremonial, it existed before there were gypsies. There was an ancient traveler who built a Romany Patteran. After journeying all day he tarried for the night in a certain place, because the sun was set. "He took one of the

Spring

stones of the place and put it under his head and lay down in that place to sleep. And he dreamed; and behold a ladder set up on the earth, and the top of it reached to heaven; and, behold, the angels of God ascending and descending on it. And, behold, Jehovah stood above it. . . . And Jacob awaked out of his sleep, and he said, Surely Jehovah is in this place; and I knew it not. . . . This is none other than the House of God, and this is the gate of heaven. And Jacob rose up early in the morning, and took the stone that he had put under his head and set it up for a pillar" . . . that those who passed that way might know it was the House of God.

And other wayfarers following in

the paths of Jacob did find the stones
in that high place and they knew it
was holy ground, that some one had
seen God there.

When I walk or drive down some
road that refreshes my spirit, or
when I tarry for the night in a road-
side camping place because the sun is
set, and watch the moon and the stars
and the dawn, and behold a ladder
set up from earth to sky with the
angels of God ascending and de-
scending, I shall leave a witness of
my high dreams, a road sign for all
travelers, that they may know that
the way will lead them aright.

This is the Rite of the Romany
Patteran, the Ceremonial of the
Stones of Bethel.

Spring

I HAVE met with but one or two
persons in the course of my life
who understood the art of Walking,
that is, of taking walks,—who had a
genius, so to speak, for *sauntering,*
which word is beautifully derived
from idle people who roved about
the country, in the Middle Ages, and
asked charity, under pretense of go-
ing *"à la Sainte Terre,"* to the Holy
Land, till the children exclaimed,
"There goes a *Sainte-Terrer,"* a
Saunterer—a Holy-Lander. They
who never go to the Holy Land in
their walks, as they pretend, are in-
deed mere idlers and vagabonds; but
they who do go there are saunterers
in the good sense, such as I mean.
. . . For every walk is a sort of cru-
sade, preached by some Peter the

Spring

Hermit in us, to go forth and recon-
quer this Holy Land from the hands
of the infidels.

Thoreau.

Little Rituals of Beauty

THE Ceremonial of Alabaster arrives unexpectedly, usually on some busy city street. The details of its arrival are these—there will be a shop-window displaying yellow bowls and plates and pitchers, or a coffee pot, or daffodils, or a leather note-book or a blue rug. The soul stops when it has particular need of just that thing. There is an argument between one's selves, an argument which may continue for many days, even weeks. To avoid altercations, the Soul uses the other side of the street for a while. And then one morning there is much sunshine, or perhaps rain, and the Soul goes in and makes a hasty purchase.

Spring

That is the moment when one enters that great company of people who have had fellowship together through the centuries, people who have exchanged their scanty stores for alabaster boxes of purest fragrance.

The founder of the Order of Alabaster must have waited long before the perfumers' shops before she could justify her extravagant purchase. What eternal satisfaction must have been hers when the Great Prophet of the Beauty of Life called her investment good! And wherever there lives a person who believes enough in beauty to make sacrifices for its possession, there is a memorial established for her.

Spring

I HAVE never seen the balloon man sail down from the sky, clinging to his parachute of many-colored balloons, and alight with bewilderment in the midst of the city traffic, but I always feel that if I had been there a little earlier I would have seen his descension. By the time I arrive he is always prosaically selling balloons. Some mornings I think he has no right to sell them. They are not his. Any one can see that he has only borrowed them from the sky and that they are battling to escape. On Sunday mornings, when I see the little balloons so weary of their earthly leashes, I want to enlist in this aerial warfare. If I could, I would buy all the balloon man's wares and give them back to the sky. But I can

only free them one by one, a blue one yesterday, a red one to-day, a green one to-morrow. It is not that I do not want to keep these balloons. I never saw a round, unadorned balloon that I did not want to own; but I know that I cannot keep them by holding to the string. I never feel that I really possess them till I give them back to the sky. As they go farther and farther from me, beyond the street lamps, beyond the tall buildings, beyond the high towers, a rare sense of possession comes to me. I puzzle over the jurisprudence of the sky. I wonder at its paradox. I only know I must not cling to the thing I would hold fast.

Spring

AEROPLANES flying high in the sky have only a momentary influence over me, for I cannot believe them when I see them from afar. I see them; I watch them casually as I would a cloud or a bird; and then I stop at the grocery store to get a pound of butter.

But an aeroplane just leaving the earth for the sky is a different matter. I can understand it then. It skims along on the earth on which I stand. For a second it is a part both of the earth and of the sky. Then, before I am aware, it is entirely of the sky. I believe in aeroplanes when they leave the ground.

After such an ascension I cannot turn with any interest to the merchandise of earth. I can think then

only of the sky and of far places. I cannot believe in eternal living when I see it from afar; but when a friend is by me one moment and at the next seems to be a part both of earth and eternity, and then turns quietly to that distant country, I believe in the thing that my eyes cannot see. I know then that eternity must be.

Easter

THE Easter season is pre-emi- nently the season of faith in the eternal. This day, I celebrate the Ceremonial of the Immortality of the Earth. The earth can only be immortal as its beauty is stored up within immortal beings. Easter Day is my day for the collection of the beauty of all transitory things. This is the Season of the Relinquishment of Things, and it is, therefore, the time for an intensified appreciation of them. On this day I do my celestial shopping, for I may be hurried at the last and neglect important items. The list below of the things I would take to heaven with me is quite incomplete, for I have not yet

had leisure to love everything. I leave spaces for additional luggage and also for the preferences of other people.

Note: They may not let me enter with all of these, but the planning lends a sense of joyousness and comradeship to that final departure.

My Celestial Shopping List

One Tea-room, *serving cinnamon toast by a fireplace*

Hollyhocks

Periwinkles

Ink

Two Roads, *one small, unimportant; one wide, very important*

Queen Anne's Lace

A Waterfall

One Range of Mountains

Spring

Coffee

One Blue Pine Tree, a Double Row of Poplars and Two Birches

Candles, orange and blue

One Fireplace

Blue Tea Cups, *at least two*

Goldenrod

A Sunrise

One Small Island, *with large hemlock tree and little wintergreen flowers*

One Head Waiter with One Sub-Waiter

A Little Garden

A Stony Brook

A Small Post Office

Spring

*Additional
Luggage*

Fifty

Spring

Spring

WHEN the young gypsy wife dies the husband grieves for her and gives her a "patrin," a sprig of holly tree. He slips a holly leaf under the clothes at her throat, saying, "Some tells us how when we dies we are cast into the arth and there is an end of us, an' others, we goes to the *ruppeny* moon. Peraps, Sanspriel, you goes to the *ruppeny* moon up ther, as we tell the childer they does, an' live forever, never hungry, or wet, or tired, an' *balansers* to spend, and pretty clothes to wear. Oh, Sanspriel, my lass, Gilderoy will bury the silver fork, an' spoon, an' a platter, an' a knife, an' the spade guineas off my waistcoat with you, so you may use them in the moon fur your need. An', Sanspriel, our little

Fifty-two

Spring

tan! (tent) . . . I buyed it myself,
but I burns it when I buries you,
woman, jist as tho' it wur yours."

Quoted from a novel, "Tamsie,"
by Rosamond Napier.

Birthdays

IOBSERVE two celebrations on this occasion. There is a celebration in general and a celebration in particular. The general celebration is for the occasion that life is; the particular rejoicing is concerned with the fact that I was given a season ticket to the Great Event. It may not be my privilege to sit in reserved seats at circuses; I may find it necessary to ascend to the upper strata of theatres in order to witness certain dramatic presentations; but wherever life is, I purpose obtaining a box seat. If there is a fire in progress in my neighborhood, or flowers blooming, or a bishop being consecrated, or important ideas in the making,

or philosophies being experimented with, there would I be also.

Personally, I arrived on a village feast night. The Methodist Church was having a community chicken supper. They would do obeisance to my arrival, for I was no ordinary mortal. Was I not a joint possession of the village and the Almighty, since my father was the Methodist minister? Because of me there was a pause that night in the village feast. They would make gifts to the guest that had alighted from afar. They sent to my family a large chicken pie. That was the first Ceremonial with which I was connected. It gave me a mighty eagerness for all Ceremonials.

Ceremonials of Summer

Sundays

SUNDAY was created along with the sun and moon and stars and the fowl that fly above the earth in the open firmament of heaven. After having created the heavens and the earth, all the hosts of them, God must have known that there would be need of Sundays. When life is very lovely, and one has been living with trees and stars and sky, there must be Sundays. To have made the beauty and wonder of the earth and not to have set apart a holy day, wherein the people whom He had created might rejoice over the work of his fingers, the moon and the stars which He had

ordained—this would have meant poverty of spirit indeed.

What a heritage of Sabbath Ceremonies has been bequeathed to us—music and incense and priestly vestments and flaming altars, prayers, sacrifices and visions, and holy sacraments. I would not be blind to that ancient splendor of cherubim and seraphim, of holy trains that filled the temple of the King. I, too, would have my ceremonials of seeing God in his world, and of worshiping Him.

I would not have Sunday be an ordinary day and I have, therefore, given the jurisdiction of Sunday to my Soul. Fifty-two days in the year (or fifteen per cent of it), my Soul has charge of my affairs. A Soul sees things in an exceedingly interesting

way. On no day are things so much loved as on Sunday, but there is a subtle difference in motives. Sunday is my Festival of Beauty, of Loved Things, of Leisure, and of Worship. I reserve for it whatever I most enjoy—flowers, blue china at breakfast, books, important letters, special walks, colored candles at supper and waffles, pine incense and colored flames in my fire. On Sunday I would not do any work, nor say nor think nor do unworthy things. I may this day announce to the people whom I like the fact that I do like them.

I think God must take pleasure in the joyousness that awakens me on Sunday mornings.

Liturgies of Common Things

THE story of the discovery of coffee is not preserved in the annals of the world's history. Legendary accounts, however, give the credit to a "flock of sheep, accidentally browsing on the wild shrubs, with the result that they became elated and sleepless at nights." Some one should have filed the date on which that flock of sheep showed the first signs of animated insomnia, in order that all future coffee drinkers might celebrate it. There being no such authentic anniversary, I find it necessary to invent my own.

The Coffee Ceremonial is observed at breakfast following the first night

of camping out in summer. The only
requirement about the coffee is that
there must be enough and to spare,
so that if one talks long before con-
suming a cup, it may be extrava-
gantly poured out and the cup re-
plenished with a hot supply. This
libation is extremely important in the
Ceremonial, and it must not be con-
sidered prodigal. A superior flavor
is noticeable in the coffee if there be,
in addition to the coffee, many divers
views and theories and at least three
chosen books which never get a hear-
ing.

It is fitting to have coffee discov-
ered by that "flock of sheep," for
coffee is a gregarious beverage. It is
essentially social; it cannot be drunk,
with any degree of success, alone.

The consequent enthusiasm must be shared with one's fellows. Good coffee is good, not because of blends or grades but because of sociability and leisure. The best coffee is Sunday morning coffee, or camp coffee, or afternoon coffee, or after-dinner coffee, or coffee which is drunk on some such unhurried social occasion.

The Ceremonial of Coffee is, therefore, a Ceremonial of Comradeship.

Of Rain A DAY of rain is almost equivalent to Sunday. Candles may be burned then and fires colored; important letters may be written and special books read. Food may be regarded with an air of importance. People may be invited in for tea. No

degree of gaiety may be forbidden, nor may any finery be suppressed. There is a gladness about rain that must be respected.

TO make a day, it took an Evening and a Morning—at least to make the first day. But that was when the world was new and there was in it only light and darkness, day and night, and God. The world has grown more complicated since that creative era. To make a day now it takes bells and whistles and clocks and desks and committees and meetings and money and a serial of daily newspaper editions, and hungry people, and people who are too tired, and luncheon engagements and tele-

Of Evening and Morning

phones, and noise and shouting and much hurrying. All these things and many others it takes now, in addition to an evening and a morning.

Perhaps these ingredients are necessary for the concoction of a day; but when I come to observe the Ceremonial of Evenings and Mornings, they do not seem to be the reason why light and darkness were separated and day and night created. Whatever be my philosophy, I, too, must work to make enough money to pay my share toward the bells and the whistles and the trains and the luncheon engagements and the privilege of hurrying.

But as I watch the stars of evening, and in the morning open my window toward the east, I shall ob-

Summer

serve the Ceremonial of quietness of
heart, of simplicity, and poise of
spirit, that I may keep my soul and
the souls of others free from en-
tanglements in the machinery of a
day.

Hotel Stationery

I LIKE hotels. I like their stationery. Hotel stationery has always the manner of one who is trying to win your approval. I enjoy the enthusiasm of it, the ready confidence that shares with any traveler the little intimacies of information that only children intrust to you on first acquaintance—what its name is, how tall it is, how many rooms it has, how many other hotels there are in the family and what their names are, to whom it belongs, how very important it is going to be when it grows up and acquires many additions. Sometimes it makes this pathetic little appeal that is irresistible, "Under New Management."

Summer

The prodigality with which the management supplies you with stationery is very flattering. It is as if the hotel clerk suspects you of having many friends who will want to be having long letters from you. When you think of it, you do have a great many friends who might want a letter. Combined with this spiritual impetus for letter-writing, there is the necessary mechanical inspiration —ink, pens, blotters, mail box, and so forth.

The Ceremonial of Hotel Stationery is to write at least one letter and to begin another which I purpose to finish at some future date. Sometime, I mean to make mention in my prayers of Hotel Stationery.

Trains

*Of
Anti-Gre-
gariousness
in Traveling*

A TRAVELER in the realest sense is not one who merely transports himself and luggage from one station to another; he is one who enjoys the transportation. He does not continuously consult time-tables nor does he sit on the edge of a seat and count telephone posts; he lives joyously en route. A traveler makes of a train a permanent abiding place, not some ephemeral headquarters that must be endured.

This real traveler may be of the gregarious variety, or of the anti-gregarious. If gregarious, he tells jokes, he argues, he plays cards, he entertains officials, he gets off at sta-

tions and converses with the assembled populace. The anti-gregarious traveler prefers scenery and silences, letters and magazines. He has looked forward to freedom of thought on that trip; he has mighty spiritual enterprises to launch.

It is for the latter traveler that I would make a little plea. Do not misunderstand him. He is not unfriendly, nor unkind. He merely wants to be unattended save by his thoughts. He has had an unusual experience which his soul desires to assimilate, or he anticipates some extraordinary event for which he must prepare himself. Do not introduce him, in the initial moment of his journey, to some friend "who is going all the way." If you are a fellow trav-

eler, do not thrust upon him some half-acquaintanceship which you may have had with him. Do not make it necessary for this traveler to linger politely behind at the porter's step until all of the double seats are taken. Do not force him to retire to the day coach or the observation platform or the diner or behind some newspaper. Do not compel him to feign some extreme busy-ness. Solitude is the divine right of every traveler. Therefore, I make a little petition to those who inhabit trains. I would have them first classify their fellow travelers into the two groups, gregarious and anti-gregarious; and for the latter, I beg that they observe the Ceremonial of Anti-Gregariousness; that whosoever on trains desires it may

have the companionship of the silences.

THE external rites of a Pullman porter are a source of joy to the lovers of ceremonials. The manipulation of sheets and pillows, towels, tables, "brush-offs," is no mean art. Their fastidious observance of the little niceties connected with Pullman equipage makes them worthy of the fellowship of the most exacting Pharisees. The obsequious rites of the tipping system lend an air of prestige that removes it from the realm of commercial enterprise.

Of Pullman Porters

THE traveler who has no artistic appreciation of the little formalities of life should not resort to diners

Of Food

for food. One does not go to a diner merely to secure nutritious returns.

The diner was not designed for people with such materialistic motives. But if the traveler be one who takes delight in outward forms and ceremonies, he will find compensation in the charming concomitants of food: the flattering eagerness and enthusiasm of waiters, the deference shown to one's slightest wish, the extravagance of linen supplies, the ear screws in the corn-on-the-cob, the frilled paper hosiery of spring chickens, the post card on which one may send back messages to friends, the show of dishes and silver, the final concern of the steward, the finger bowls, the after-dinner mints, the prosperous-appearing p l a t t e r on

which one leaves one's tribute to the Ceremonial of Dining En Route. What more of recompense could one want!

O UR Father, we thank Thee for all the people who have been a part of this day of ours—for the hurrying ones on city streets, for the watching crowds in the stations of little towns. We cannot forget the faces of these people waiting at little stations. Did they come down to our train with hungry human hearts, eager for comradeship with the world beyond their doors? Were we faithful to this high comradeship, or did we answer back with cruel casualness? Dare we pray that they may find fulness of living?

A Prayer on a Train at Night

Summer

And if to-night, Thou Father of Lights, there are people standing out there in the darkness, watching our lighted train and reaching out for the far spaces of life, may we be to them the shining symbol of their great desire, a winged flame that shall rekindle in their hearts the light of joy and hope and love.

We would pray for all the busy people who have stopped at their tasks in field or home as we have gone by this day. We thank Thee for this fleeting friendliness with all these workmen of the day. Wilt Thou give them rest to-night.

We thank Thee for the little children who wave at trains. Let not life fail them in their high anticipation.

Seventy-six

Summer

For this great household of thy
children, strangers all, but gathered
under thy roof, we ask thy evening
blessing. If in the business of this
day we have forgotten Thee, may
the night draw us to Thee. Thou
hast watched over the tented travel-
ers of other nights; we, too, need thy
care.

We thank Thee for the wonder in
the hearts of these children who are
being put to bed, their wonder at the
lights, at the miracle of Pullman cars,
and at all of their strange neighbors
of the night. In the presence of the
daily miracles of thy world may we,
too, wonder with a wonder childlike
as theirs.

We ask Thee to remember those
who are guiding our train through

the intricate pathways of the night.
Wilt Thou watch with them as they
watch over our safety throughout
this night.

We would not forget that there
may be tired and hungry ones on our
train to-night, hungry because they
have no money for food, tired be-
cause they have no place to sleep.
Perhaps some are on their way to
face great sorrow; others, to find
friends and sharers of joy. And
there may be those who are hurrying
to strange lands and far, alone. Use
Thou our human hearts to reveal the
reality of thy Presence. Open Thou
our hearts that we may understand
each other's suffering, each other's
joy. In the silences of this journey

may the unworded cries of human need be heard and answered.

Wilt Thou in thy love remember the loneliness of our own hearts. How didst Thou dare to trust us so?—to give us the loveliness of human presences, and then to make the distances, too, and trains that take us out into the darkness of the night. Our hearts are gladdened by thy trust.

And before we sleep, we would thank Thee for the stars.

Lead us into the new day joyously aware of life, of beauty, and of the spiritual presence of those whom we love.

Amen.

Private Ceremonials

Ceremonials of Autumn

The First Fire of Winter

THE first fire is the symbol of winter's arrival. Winter comes not in calendar compartments; it comes with the advent of fire. When the air becomes resonant with the chopping of wood, when I see the smoke ascending from neighbors' chimneys and smell the fragrance of wood burning, I know that winter is here.

On my own altar, I, too, make radiant sacrifices of flame and redolent offerings of wood-incense. I bring forth the driftwood blazes which I have collected for winter use: blue mountains and oceans, pine trees with white paths going in between,

stars seen from a windy hill, a river road with dogwood trees and red maple, clover in blossom, words spoken, and silences. With such colors are the flames tinged, with blue and green and yellow-orange and with the indescribable lure of words spoken and of silences.

The fire throws into bright relief hieroglyphics hitherto unrevealed on the sensitive parchment of days that went too swiftly by. In flaming magic the histories of forgotten hours are reproduced. As the fire burns, the illuminated pageant sweeps on. My newly acquired possessions must pass in spiritual review; the worthiness of investments must be tested. At such times fire is an austere thing.

But fire is not my peculiar posses-

sion, it is the property of the gods;
nor is the Ceremonial of My First
Fire an individual ceremony—it be-
longs to the gods, also. All the gods
who have ever been worshiped through
the medium of fire are summoned to
this Festival of Fire. A strange
company they make in the shadows
of the room, attended by priests and
dancers and winged messengers of
flame. Silently my celestial guests
lay their gifts upon the humble altar
and I am left alone with a little wood-
fire in a small red brick fireplace—
but now it is no longer an ordinary
receptacle for burning wood, it is
consecrated with a loveliness that
shall make it worthy of the comrade-
ship of a winter.

Autumn

KNEEL always when you light a
fire!
Kneel reverently, and thankful be
For God's unfailing charity,
And on the ascending flame inspire
A little prayer, that shall upbear
The incense of your thankfulness
For this sweet grace
Of warmth and light!
For here again is sacrifice
For your delight.

John Oxenham.

November the Eleventh

THERE is, on November the eleventh, a Ceremonial of Maps. I stand before the maps of the world: before the rain map and the map of winds, and I know where rain is falling and where wind is blowing; before a road map of the world, and I see the roads of all lands, and people traveling on them; before a train map, and watch the trains going up and down the earth with pilgrims, guided, all, by a pillar of cloud by day and a pillar of fire by night; before a map of the lights of the world and the fires; before a map of the trees and of birds; before a map of the homes of the world, and of the uncharted regions of human hearts,

which in all lands are fashioned alike. What possessions we have in common—rain and wind and roads and trains and lights and fires and trees and birds and homes and hearts.

On this day I go into all the world. I stretch out my hand to lay hold of the uttermost parts of the earth. National boundary lines are converted into bonds of union, making of the nations of the earth "a perfect round," a harmonious whole. When enough of us are prepared in spirit to inherit the earth, there will be a leader worthy of guiding that mighty fellowship. I make room in my heart for the inheritance of a world.

Autumn

WHEN the kingdoms of the world have passed before me, I close my eyes that I may perceive that mightier kingdom, the kingdom of the spirit. I re-see people in terms of spiritual values.

Of Scaffolding

I see human forms and all of the material creation as scaffolding for the spirit. When the human spirit is ready to be launched on the infinite seas, the scaffolding will be thrown aside and the spirit will slip out to sea, unencumbered, yet grateful it will be for the things of the earth that prepared it for its long voyage. All things will be hallowed that helped to shape it for that eternal launching.

Sacred, for me, will be the western prairies, the mountain streams, the

lake paths, the sunrises seen above neighboring chimneys, the quiet walks along a village street, the gardens, the fragrance of old-fashioned flowers, the moonlight falling in my room, and rain at night with trees blowing. How much these things and others shall have shaped my spirit, I shall not know, but of their daily fashioning I am aware. As my spirit, dominant and eternally adventurous, shall enter the vast seas, I shall not forget the sacramental service of the scaffolding of earth.

Thanksgiving

ON Thanksgiving Day I cele-
brate the Ceremonial of
Being Glad for People. I
could be grateful on this day for
bountiful harvests and national
benefits; but I have other days for
those ceremonials because one heart
is not spacious enough to hold the full
measure of all gratitude. A year is
a lean year or a year of plenty in pro-
portion to the poverty or richness of
its fellowships.

I would give my thanks for the
people whom I have but glimpsed in
passing: children watching at win-
dows; those who sell flowers, espe-
cially little boys who trust me to buy
their violets or dogwood branches;

porters on trains and in hotels; post office employees who make letters possible; people on trains; nurses in hospitals; makers of music; those who sit in church with me, whom I "silently rejoice to be with."

There is gratitude for the people whom I pass each morning and evening: children on bicycles; those who go and come from work; and for the people whom it is not given to me to see—for those whom I know only through the printed page, for those who have designed certain buildings and parks and monuments, who have constructed roads, for those who sit in offices and plan for the well-being of the world, for the people around the world who work that I may have the necessities of life.

Autumn

And there are other people who bring to me joyous delight on this day. To them I write letters—to the old friends and the new. For Thanksgiving is an articulate season, a time for expressing the unspoken things of the heart.

The Ceremonial of Being Glad for People was the initial ceremonial. Because of it, the other Ceremonials were made necessary.

Ink

Especially Important to Those Who Live in Far Places

INK is a divine commodity. Why do not those who buy and sell realize that the worth of it is far above intrinsic value? Are they not aware that it conquers distances, making a highway for the hidden things of the heart? Is there somewhere an exclusive ink-shop with salesmen who are *connoisseurs* of ink, who believe in the magic of it? If there is such a business establishment, I should like to advertise their wares. I would have their *clientele* make large resolves about ink, and purchase supplies adequate to their reso-

lutions. Not all people would buy ink of them, but some there would be who would re-route a transcontinental trip to invest in their enchanted fluid.

Ink in the large fascinates me and the promotion of the sale of new bottles of ink makes a philanthropic appeal to me because of its potential service to mankind, but it is the half-used bottle of ink that demands my entire devotion. Those stationary souls who have never invested in geography cannot comprehend the problem that lies concealed in the half-used bottle of ink. They have never adjourned to some Napoleonic isle to hold sessions with a new bottle of ink. Only itinerant souls know the subtle appeal of the ink bottle

that has made visible to others the meditations of the heart. Such ink cannot be packed and yet it cannot be left behind. To abandon it would be an act of desertion, a faithlessness to a high trust. One of two things may be done with ink at the time of departure. It may be given to a resident friend, or it may be carried in the hand.

What apartments I have left, ink in hand! I shall probably arrive at the gate of heaven carrying a half bottle of blue fountain pen ink. And perhaps at that port of entry there shall be some official who will appreciate the heavenly relevancy of ink, who will classify it as a possession meet for eternity.

My Own Ceremonials

Lightning Source UK Ltd.
Milton Keynes UK
UKHW010004201121
394181UK00003B/79